STRESSED THE FUCK OUT

PARIS ALLEN

Copyright © 2016 Paris Allen

ISBN-13: 978-1537380865

ISBN-10: 1537380869

The Antidote To Your Stress.

COLOR TEST

COLOR TEST

Some of What's Inside

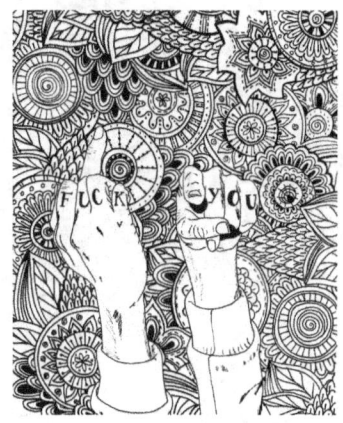

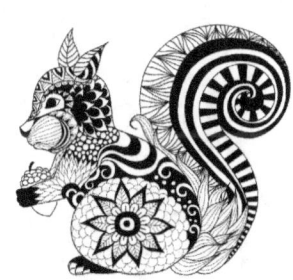
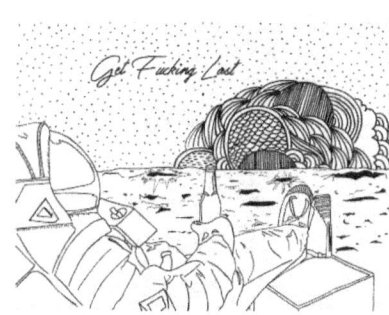
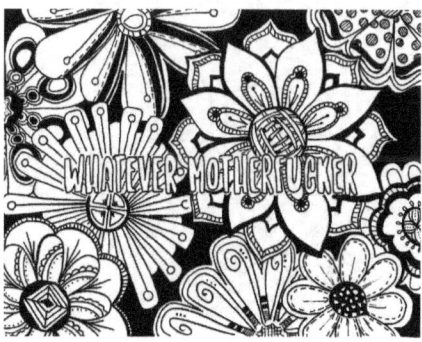

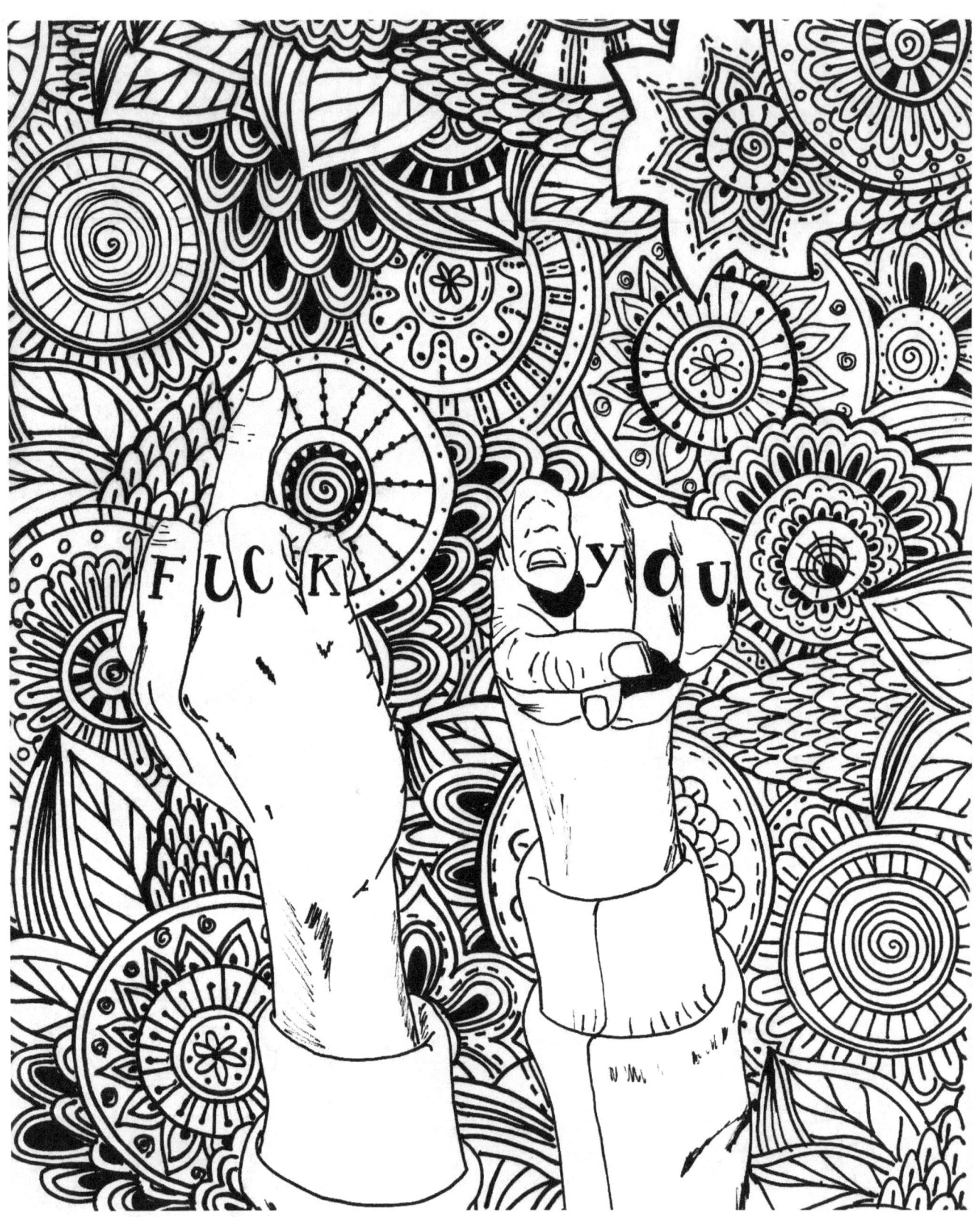

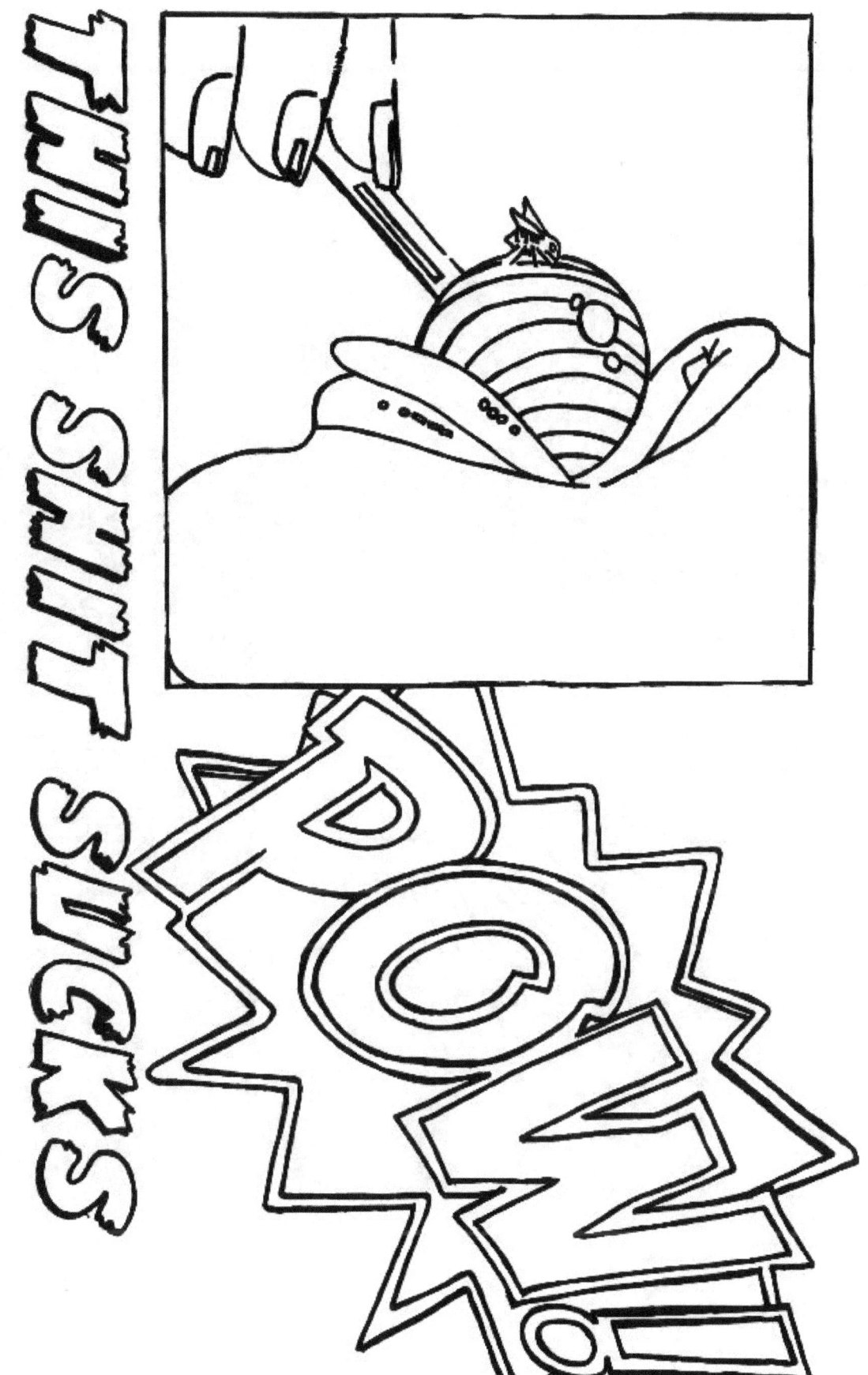

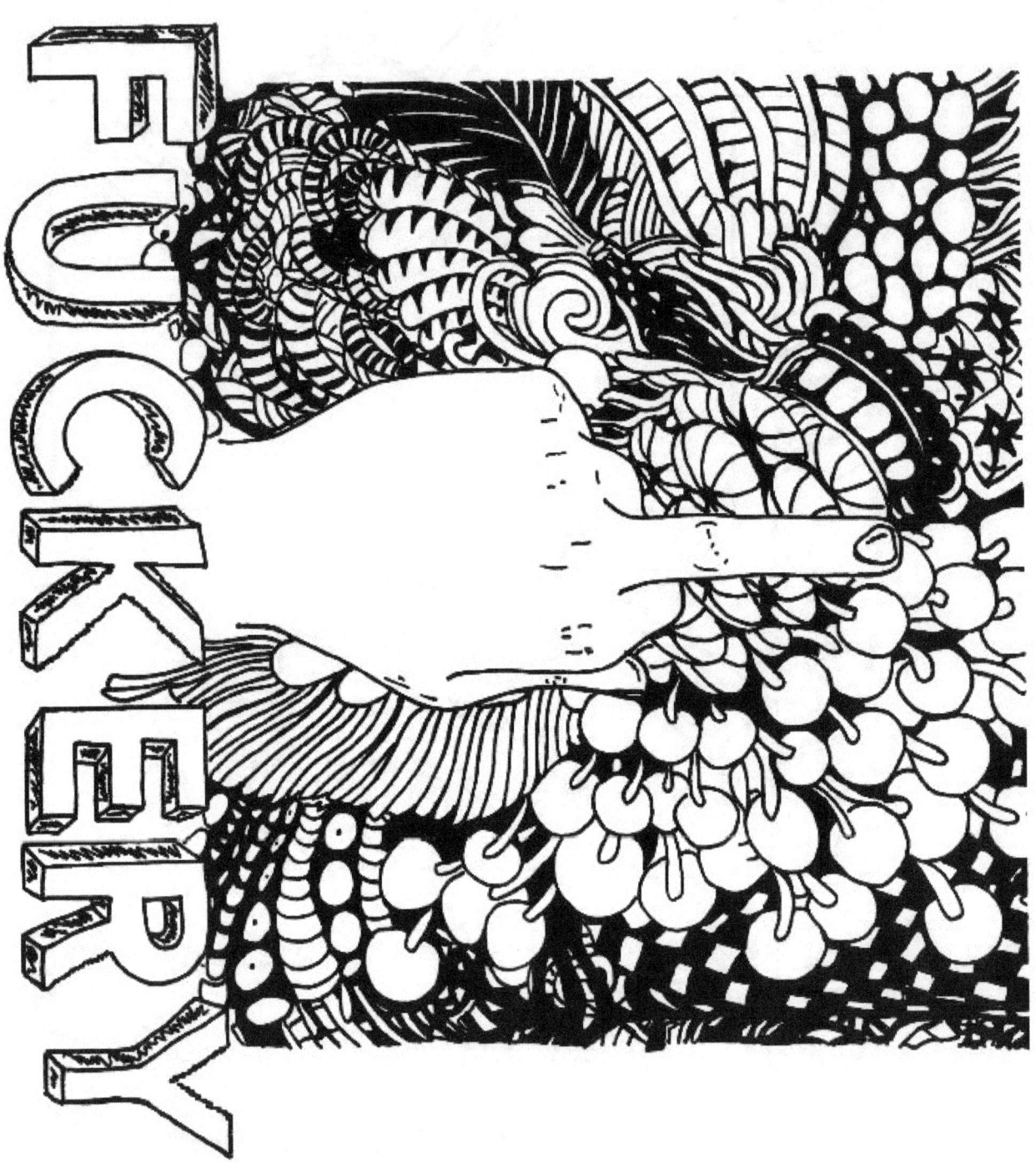

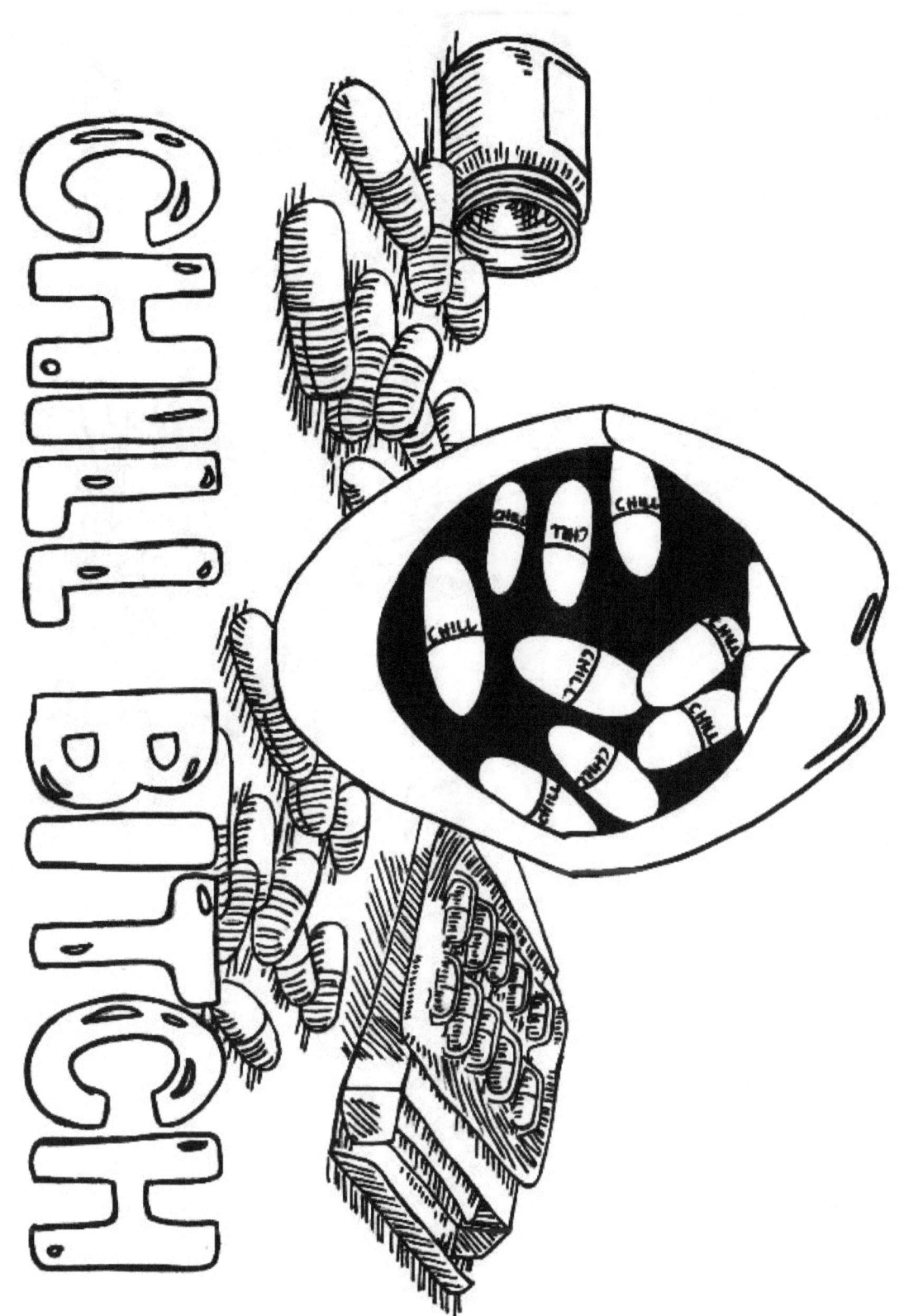

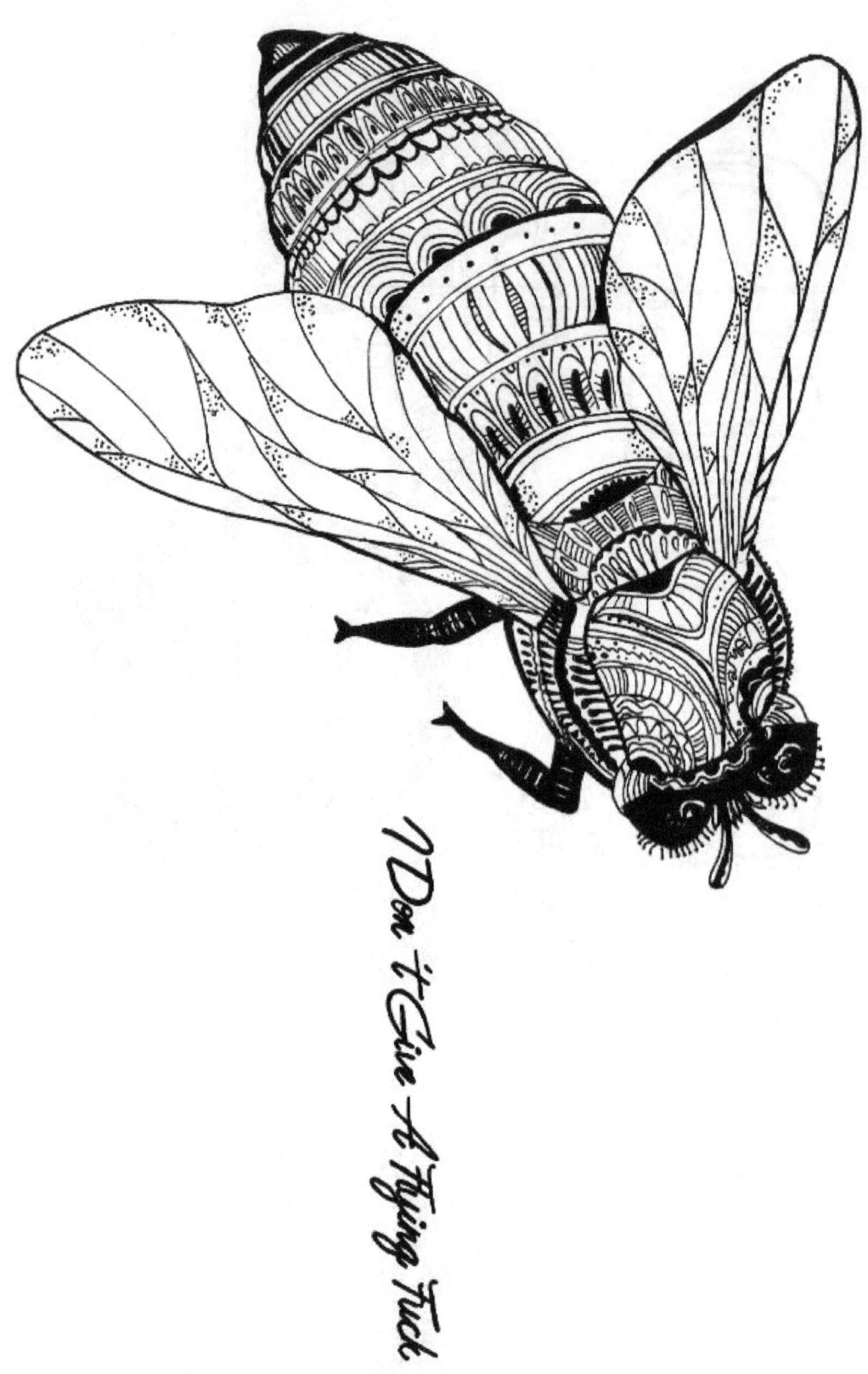

Get the Fuck out of Dodge

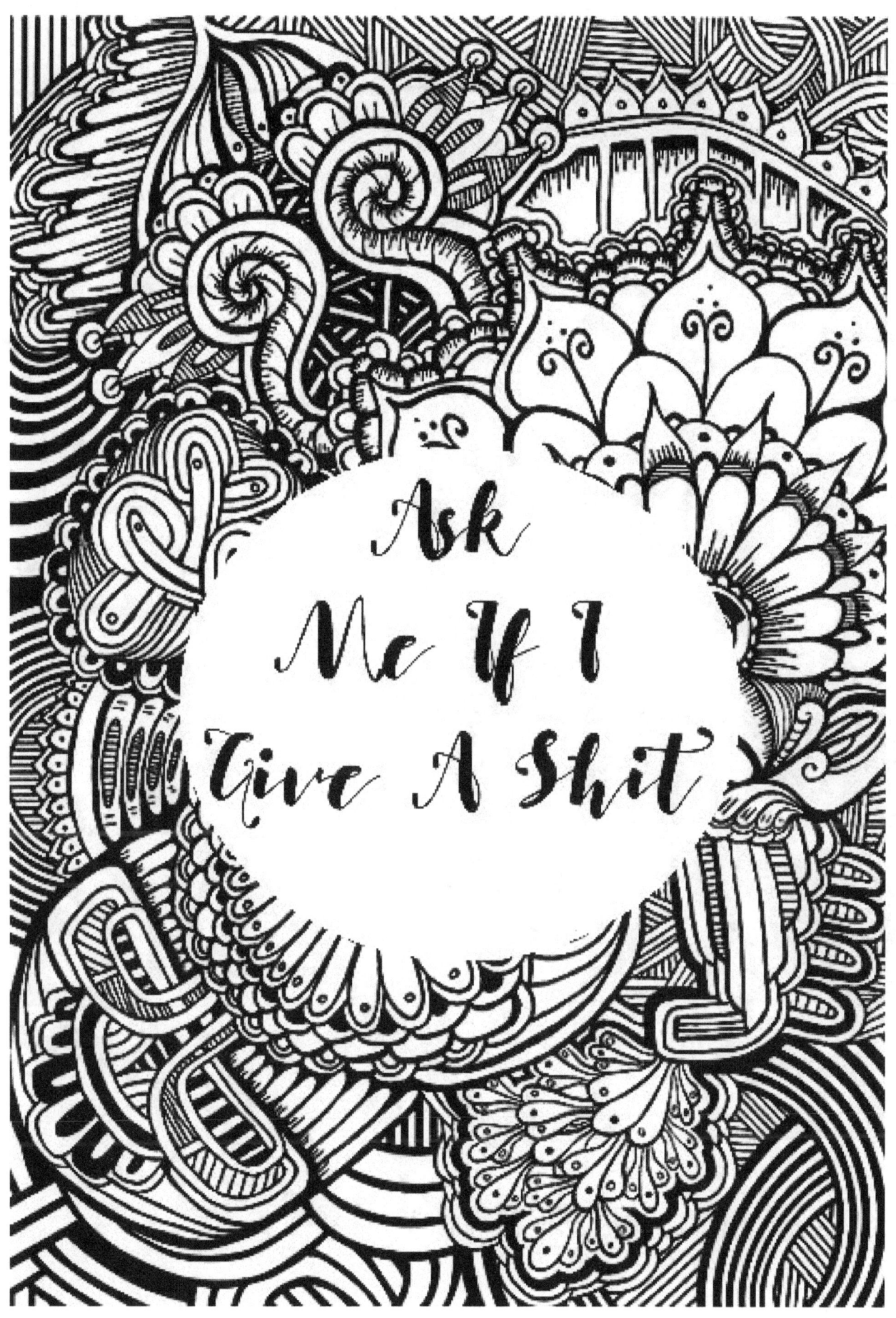

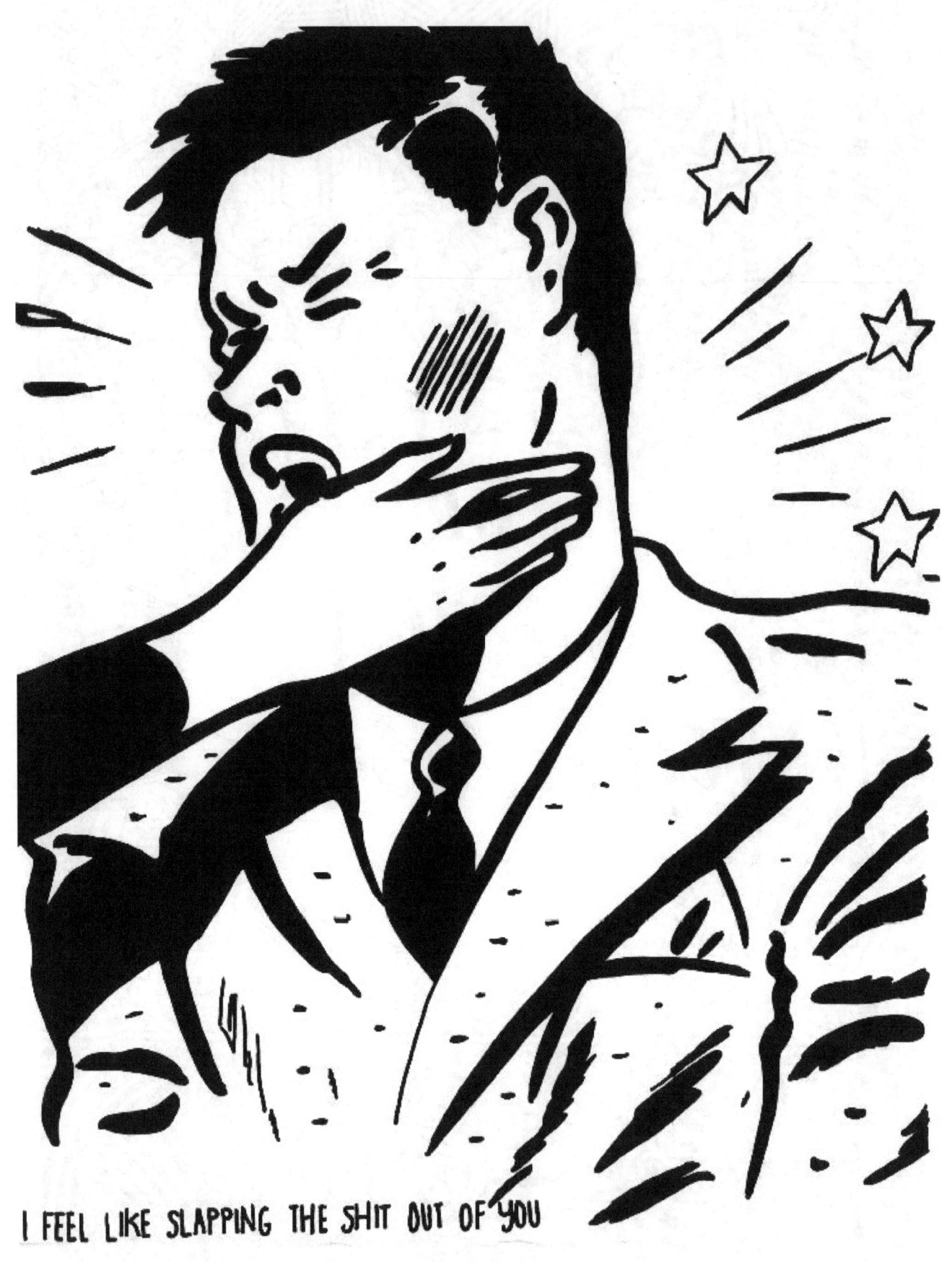

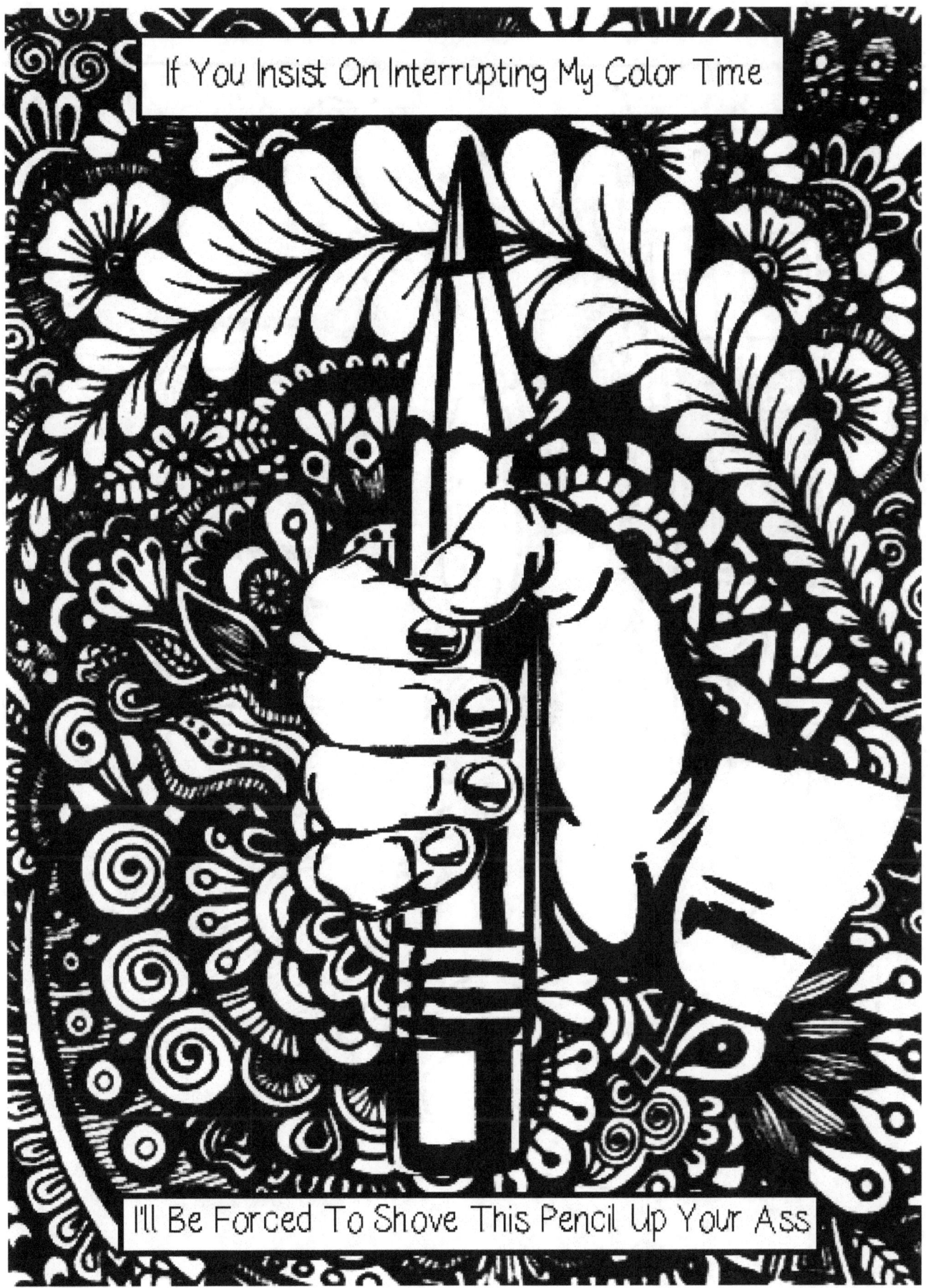

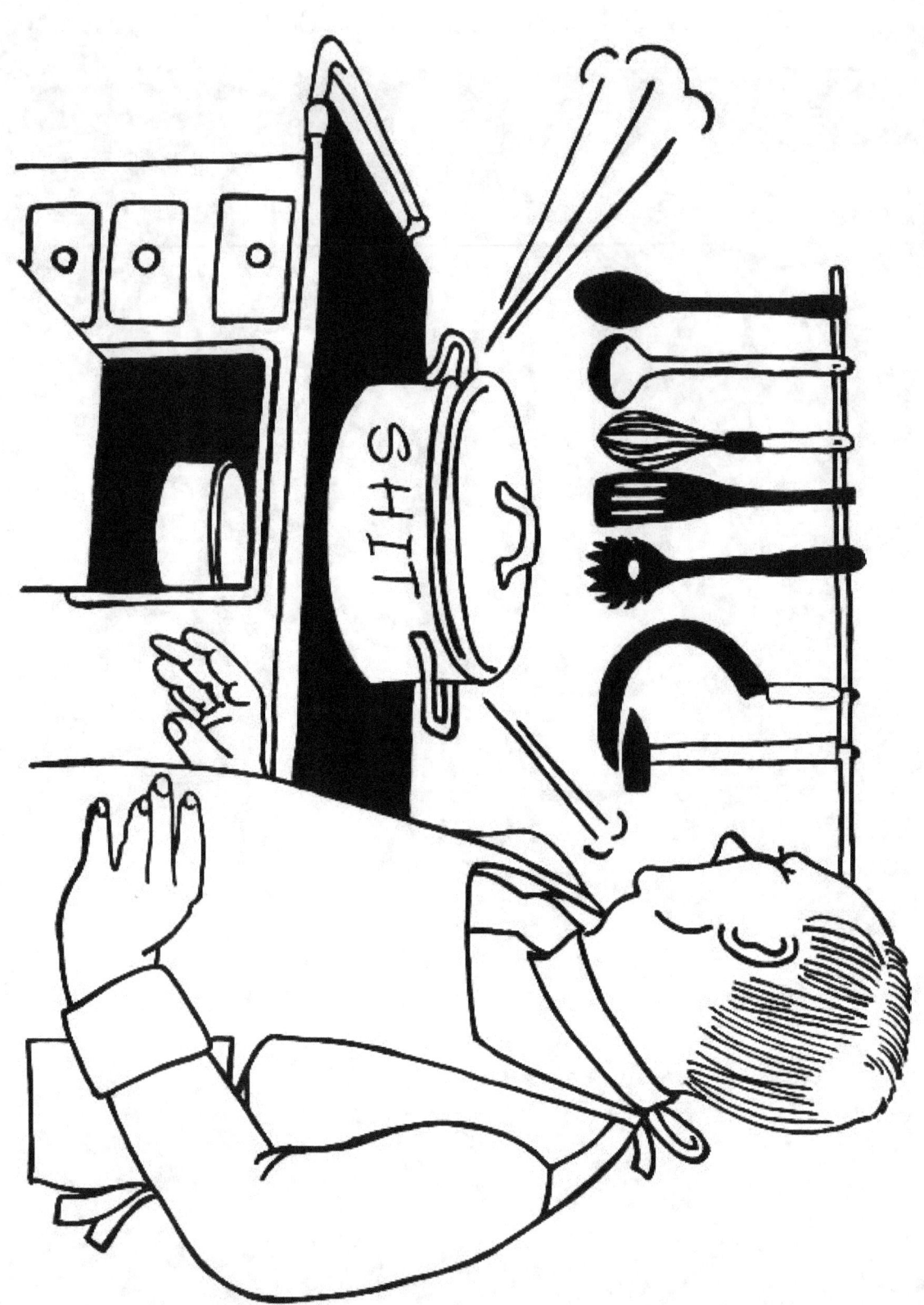

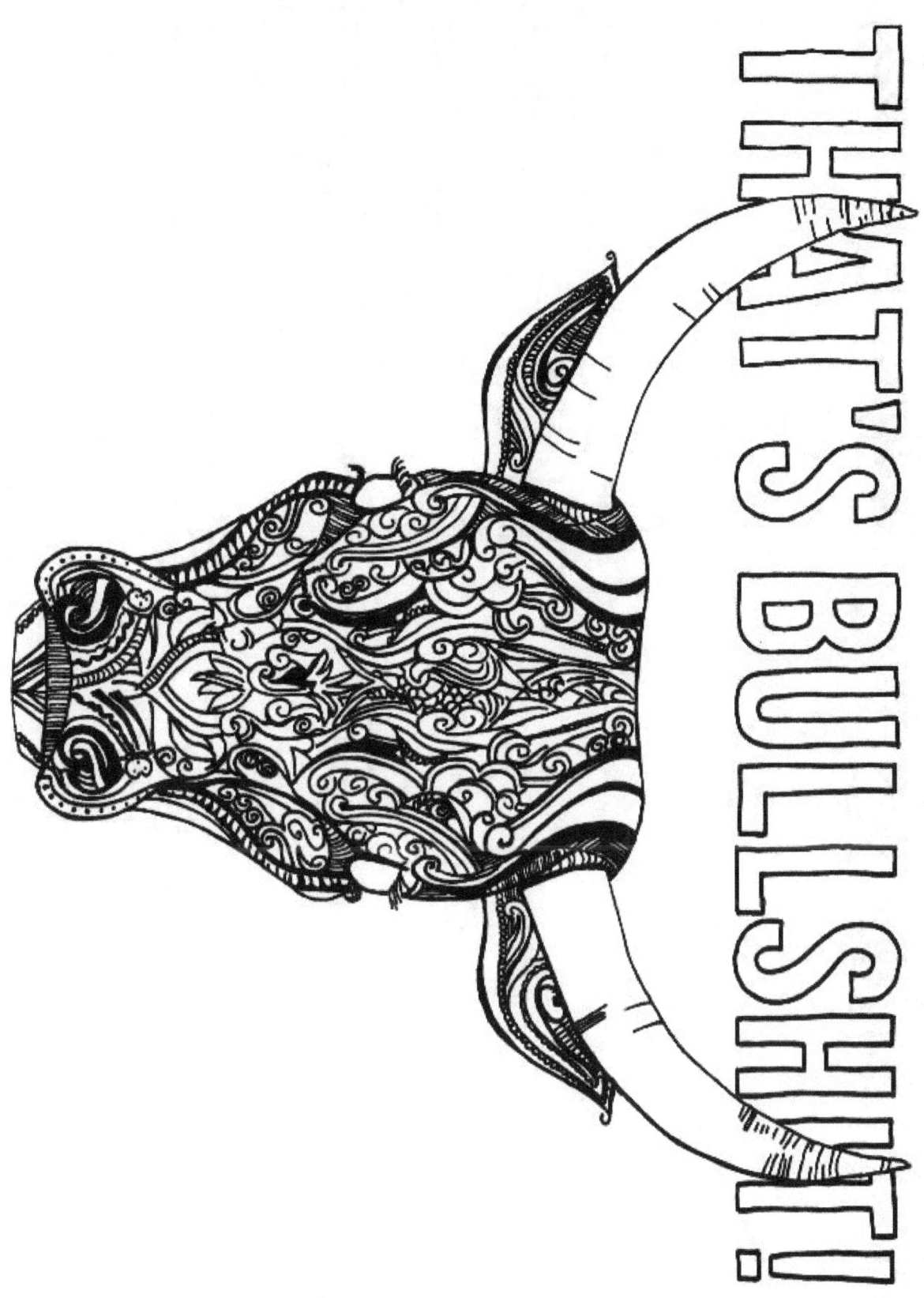

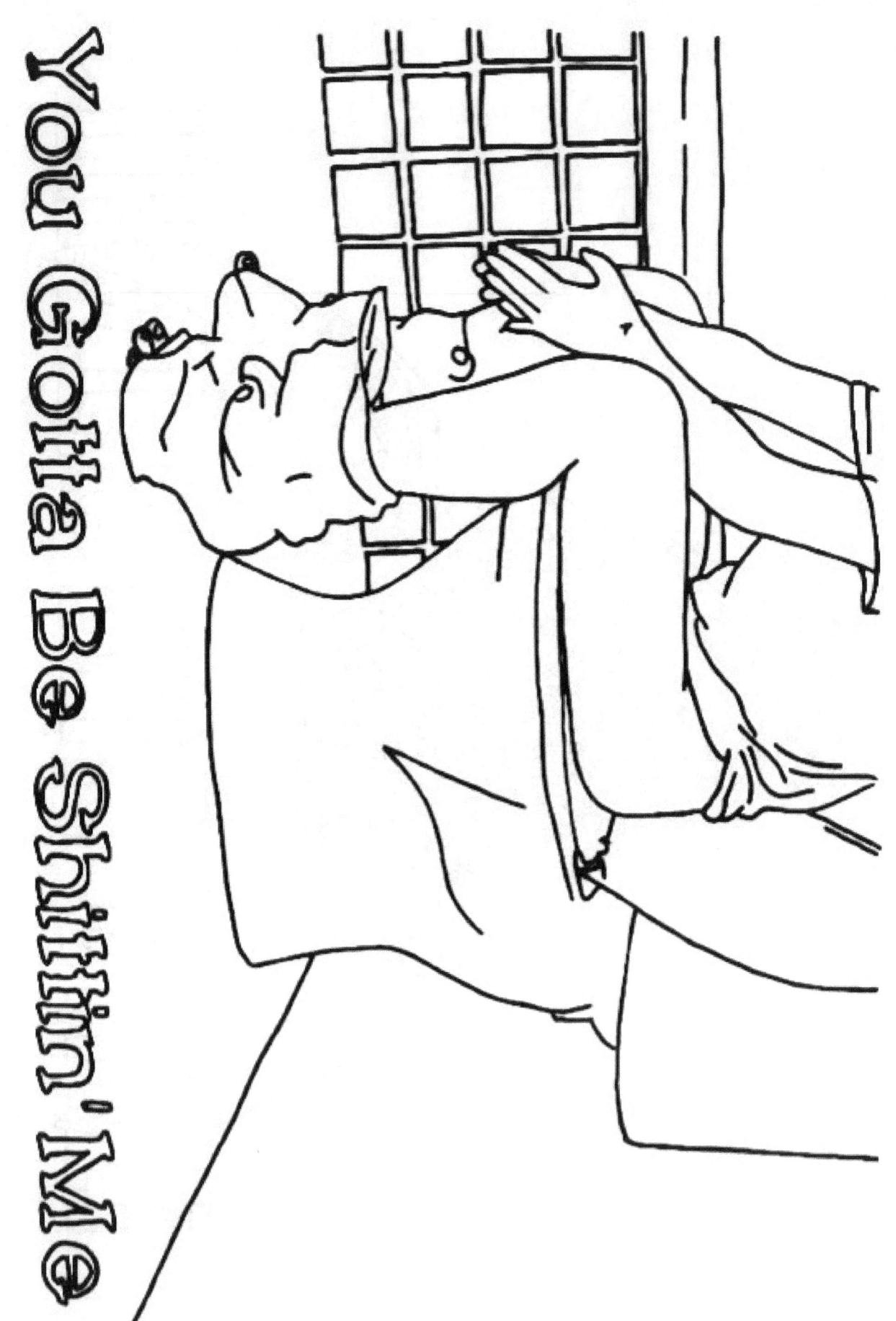

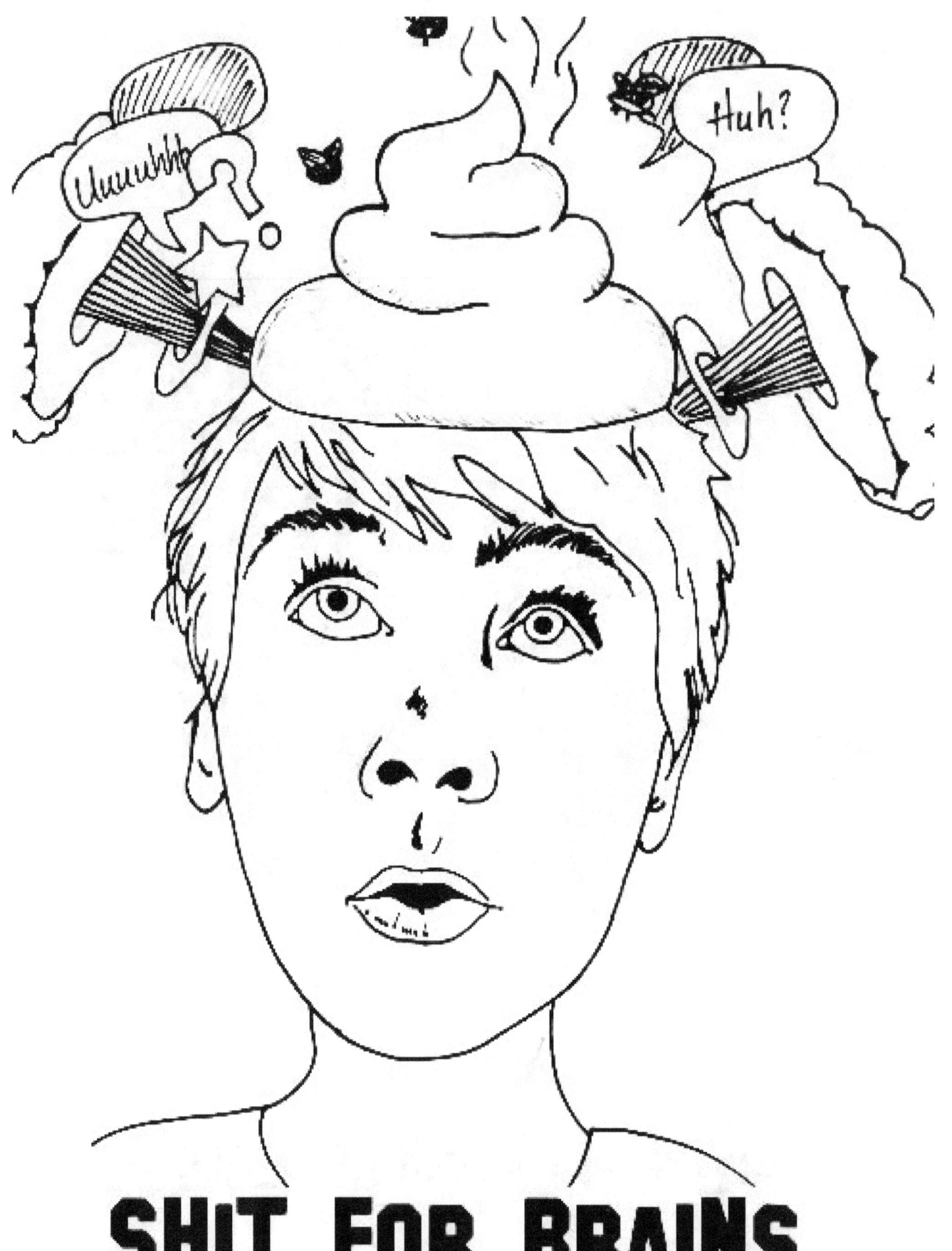

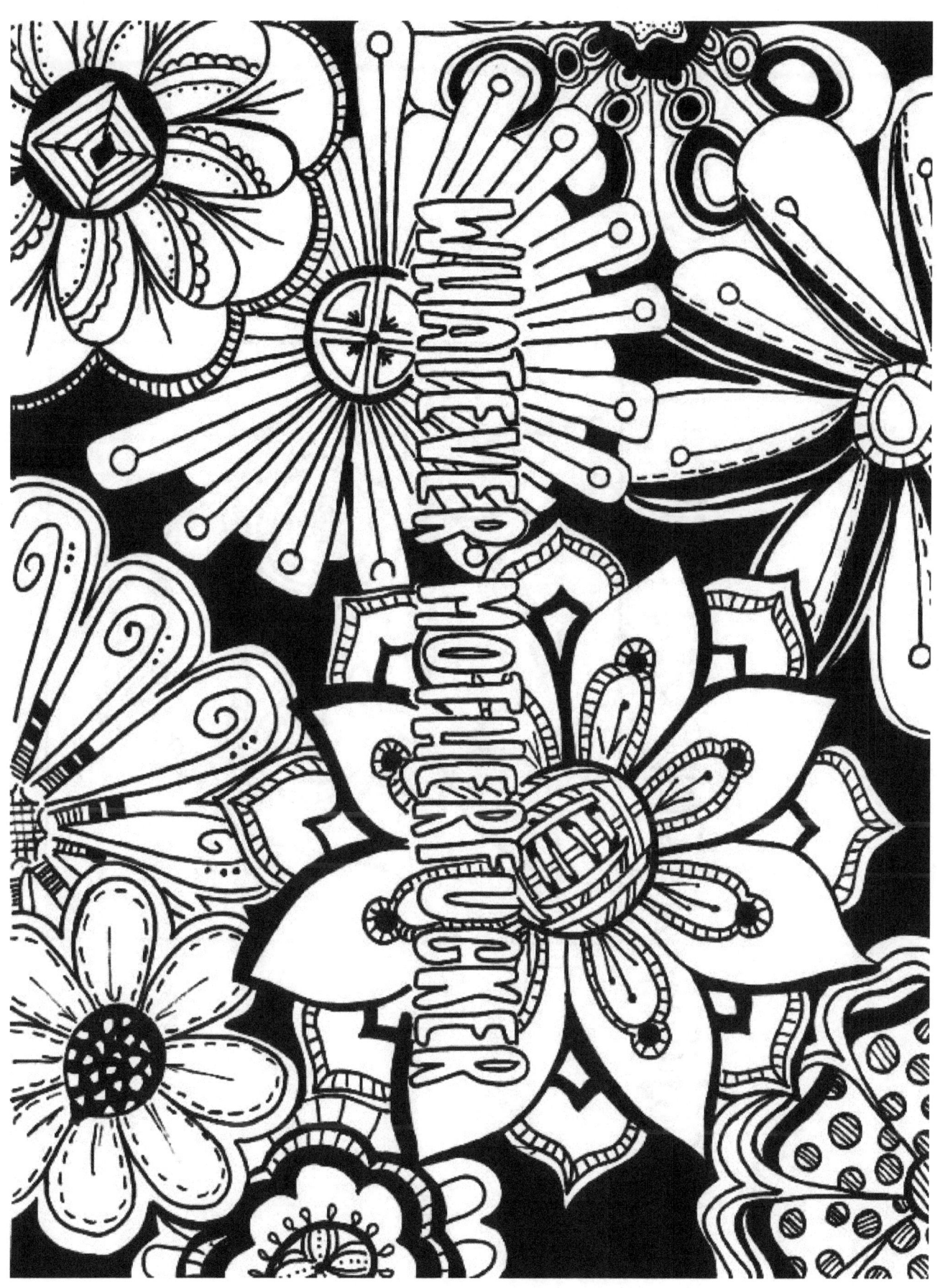

I See Bullshit From A Mile Away Motherfucker

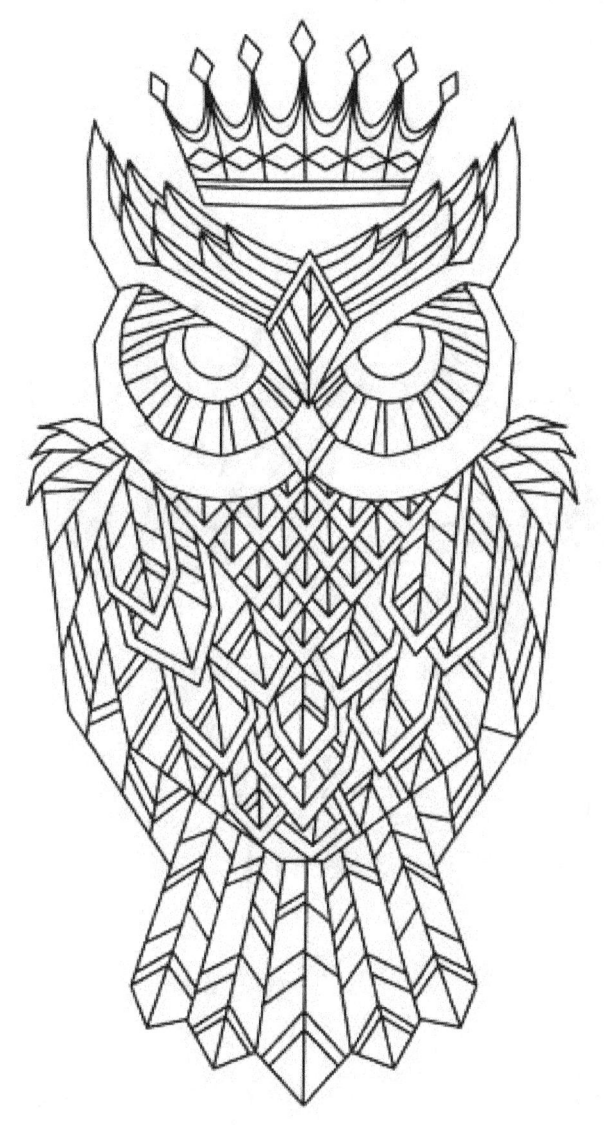

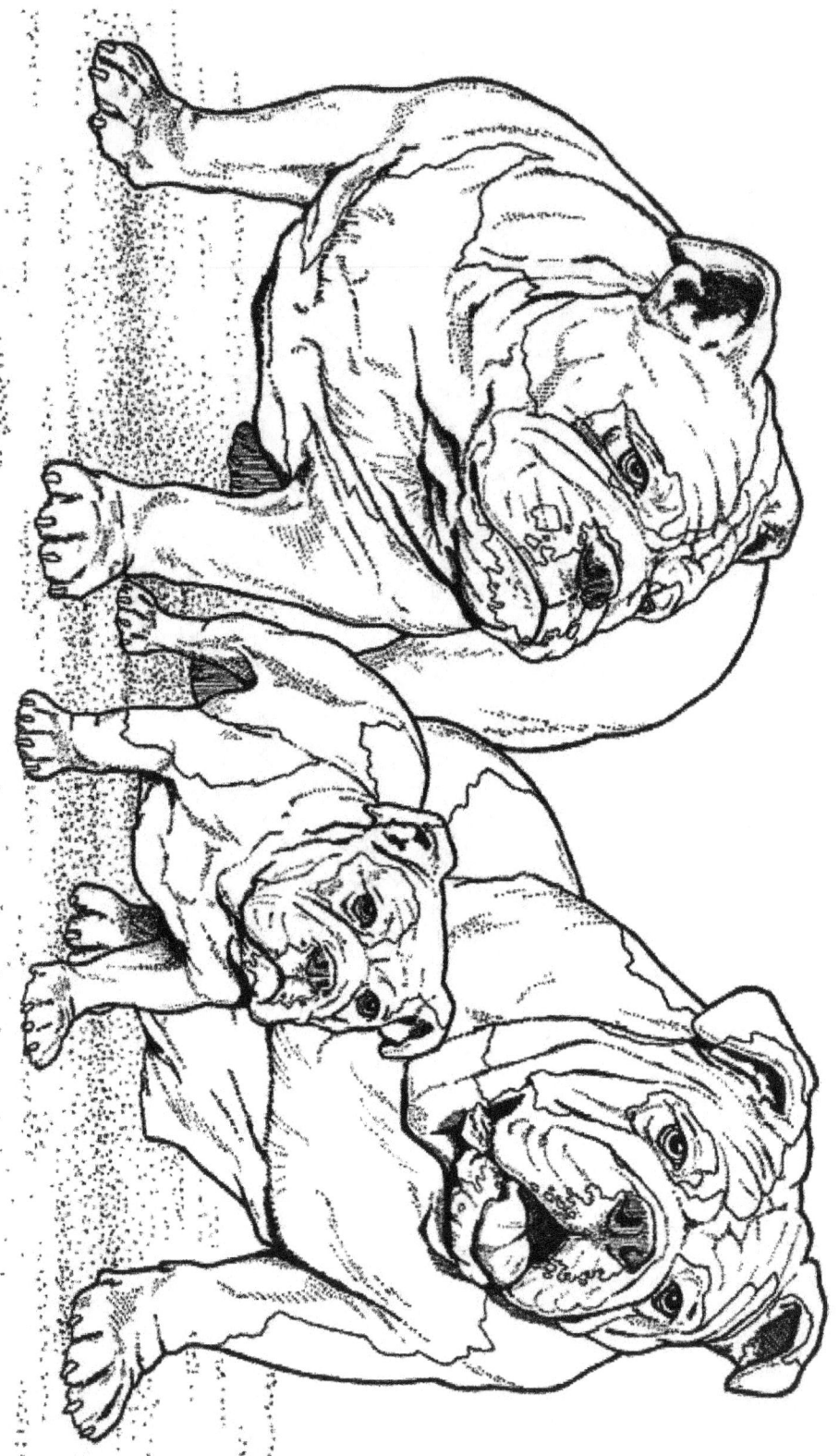

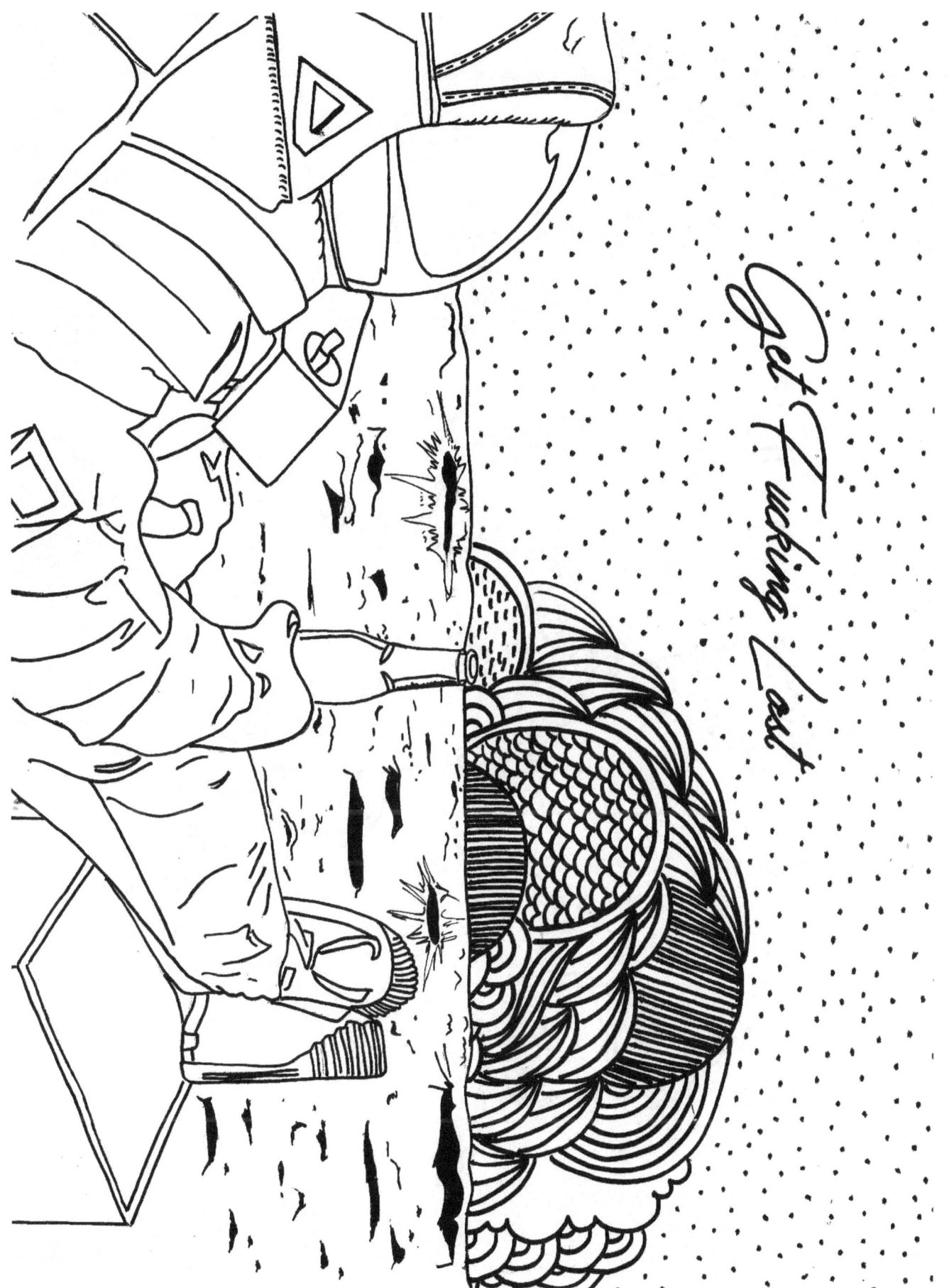

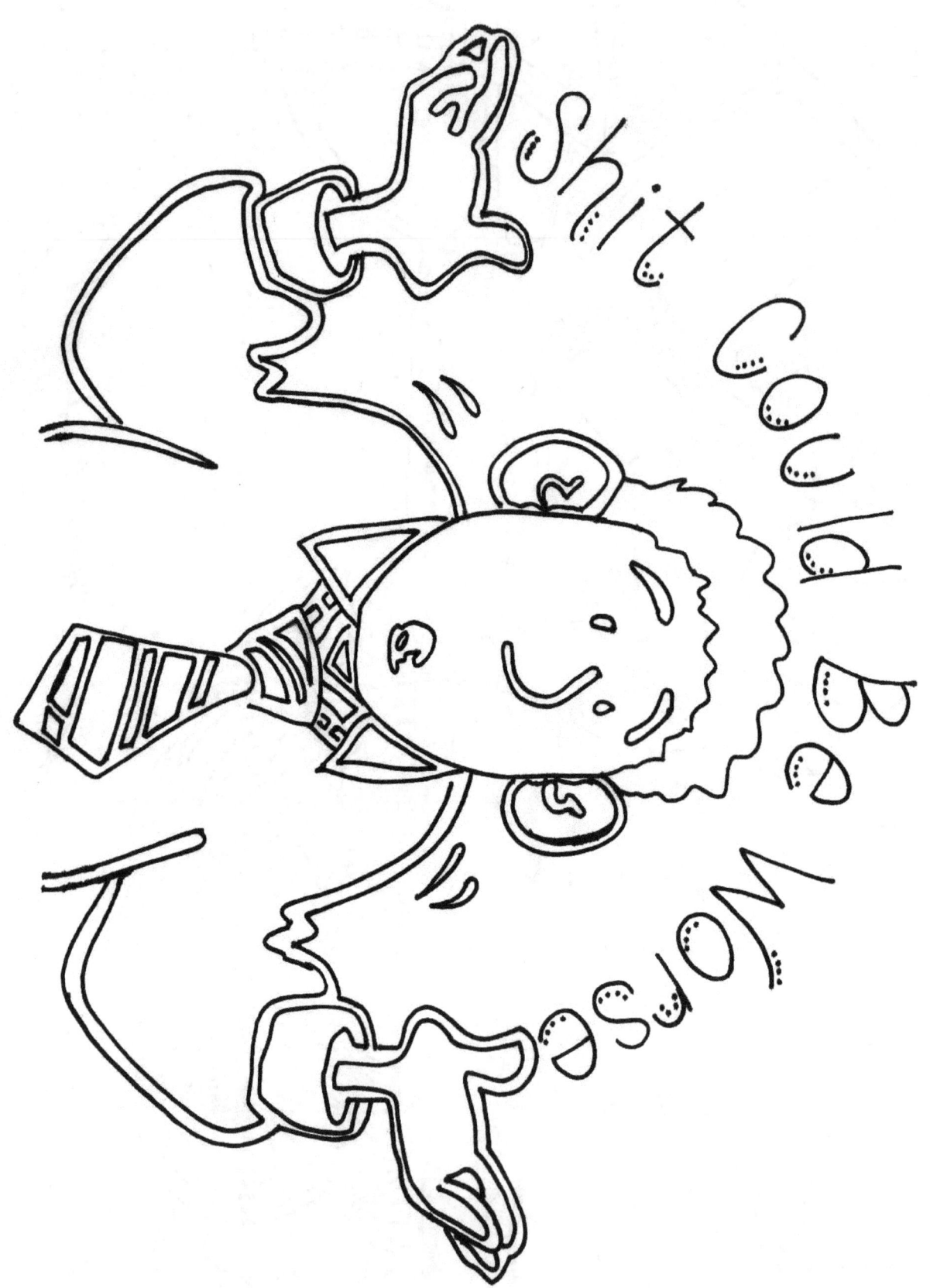

How About A Warm Cup Of Shut The Fuck Up

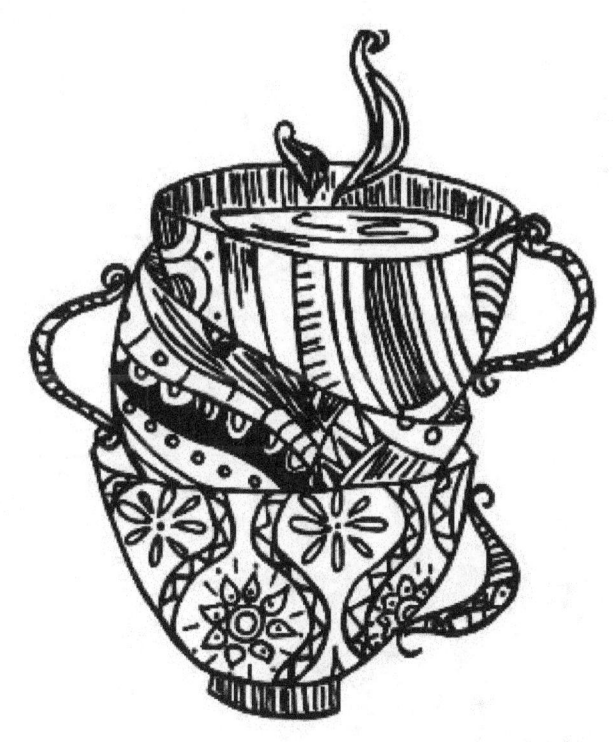

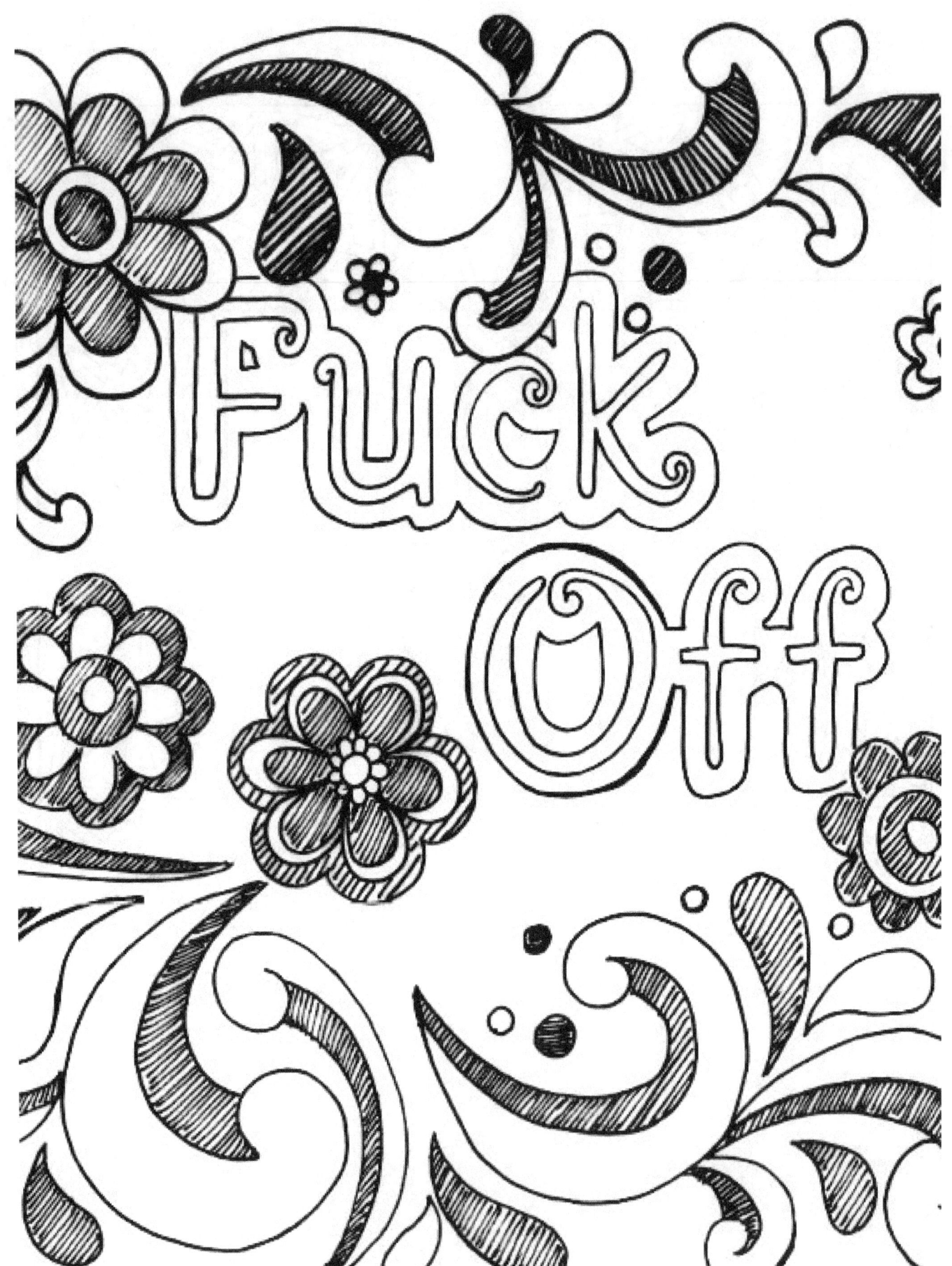

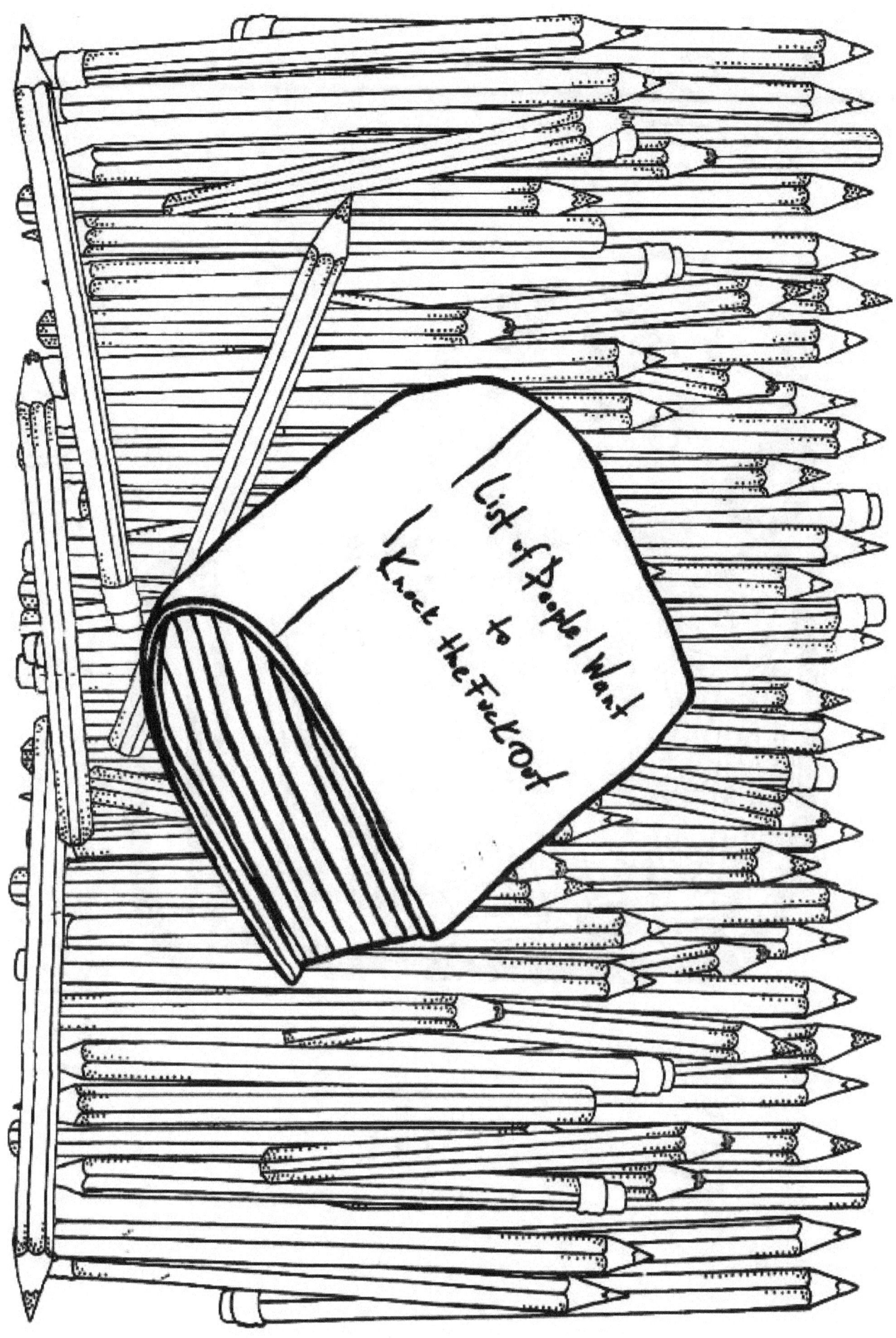

SHIT

DAMN

FUCK

FUCKING SWEAR JAR

BITCH

HELL

BASTARD

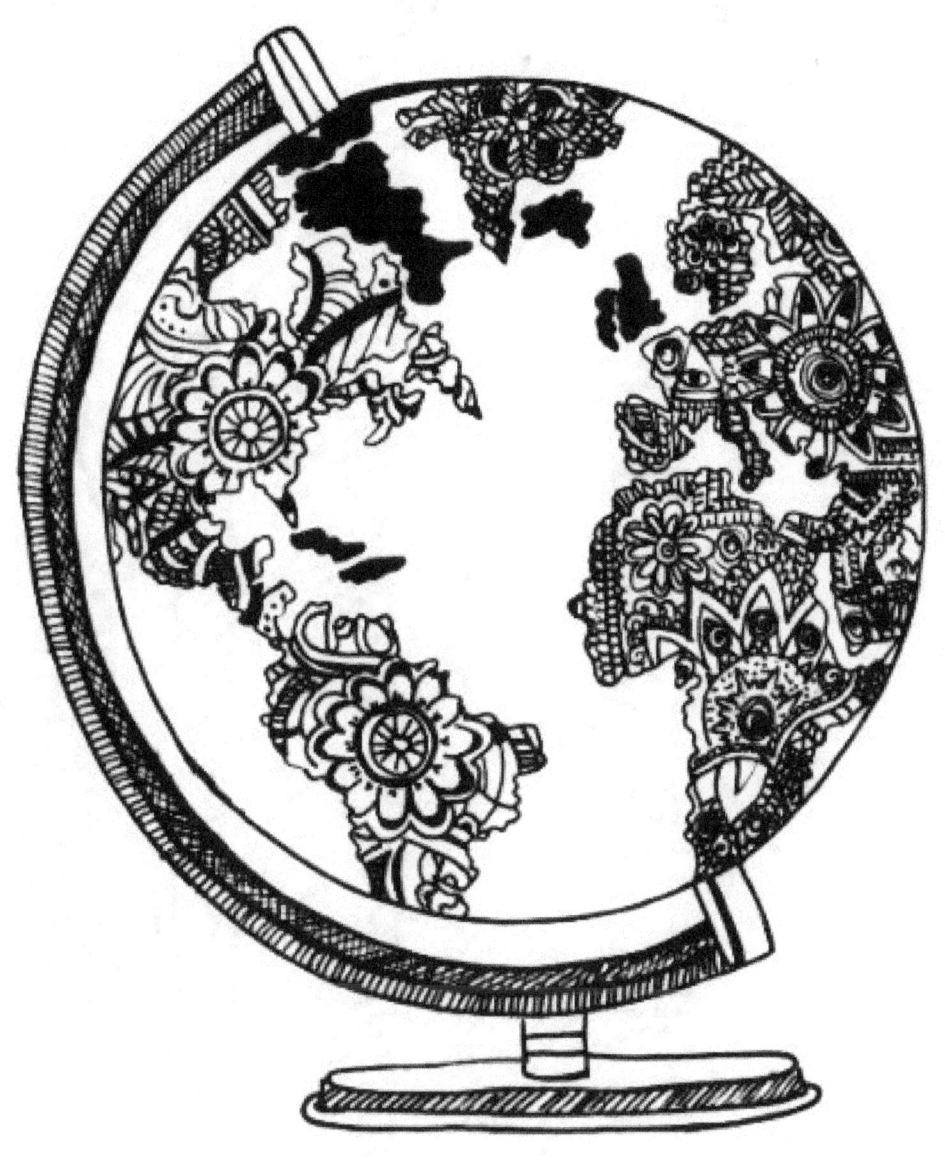

IN MY OWN FUCKING WORLD

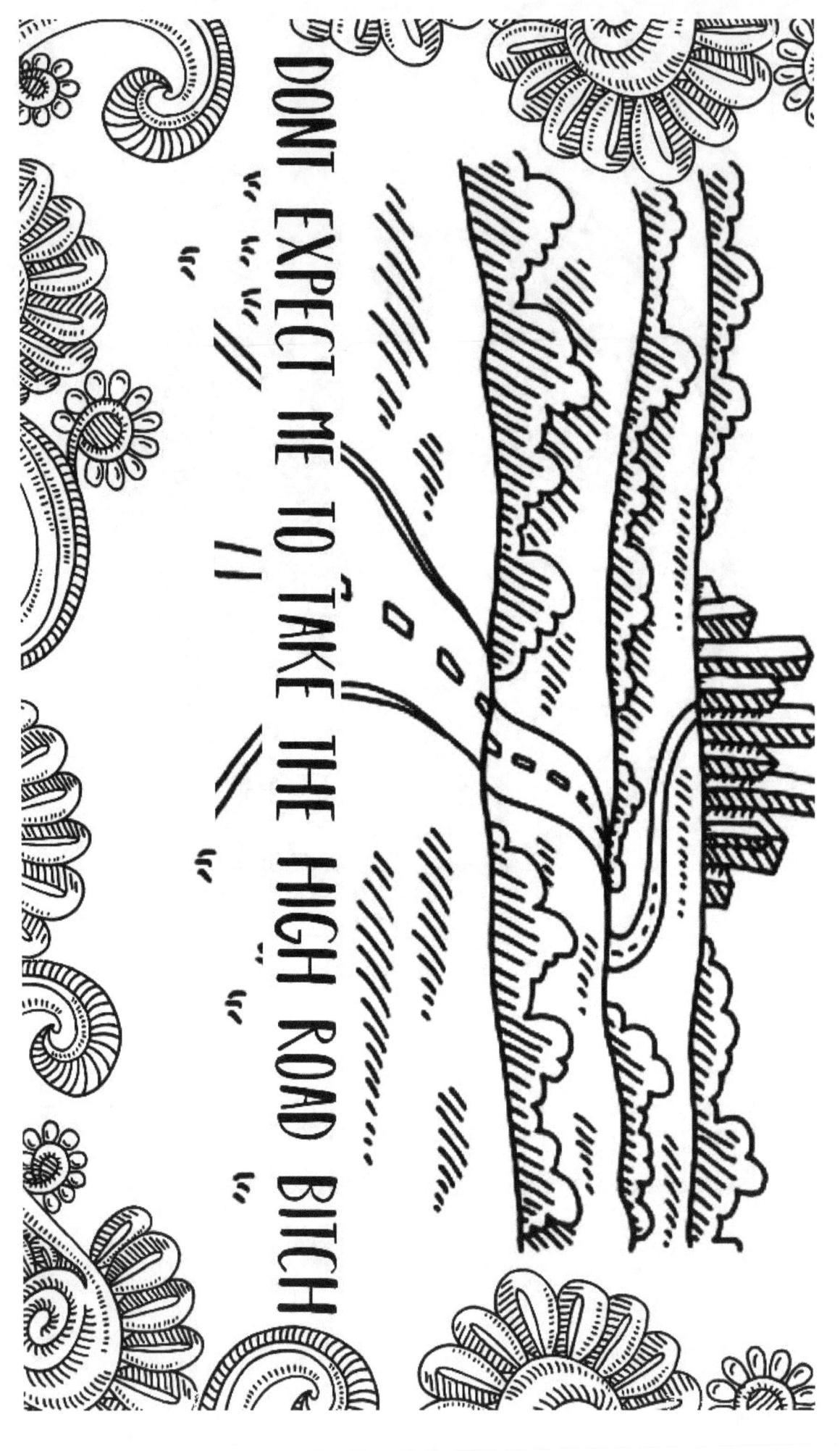

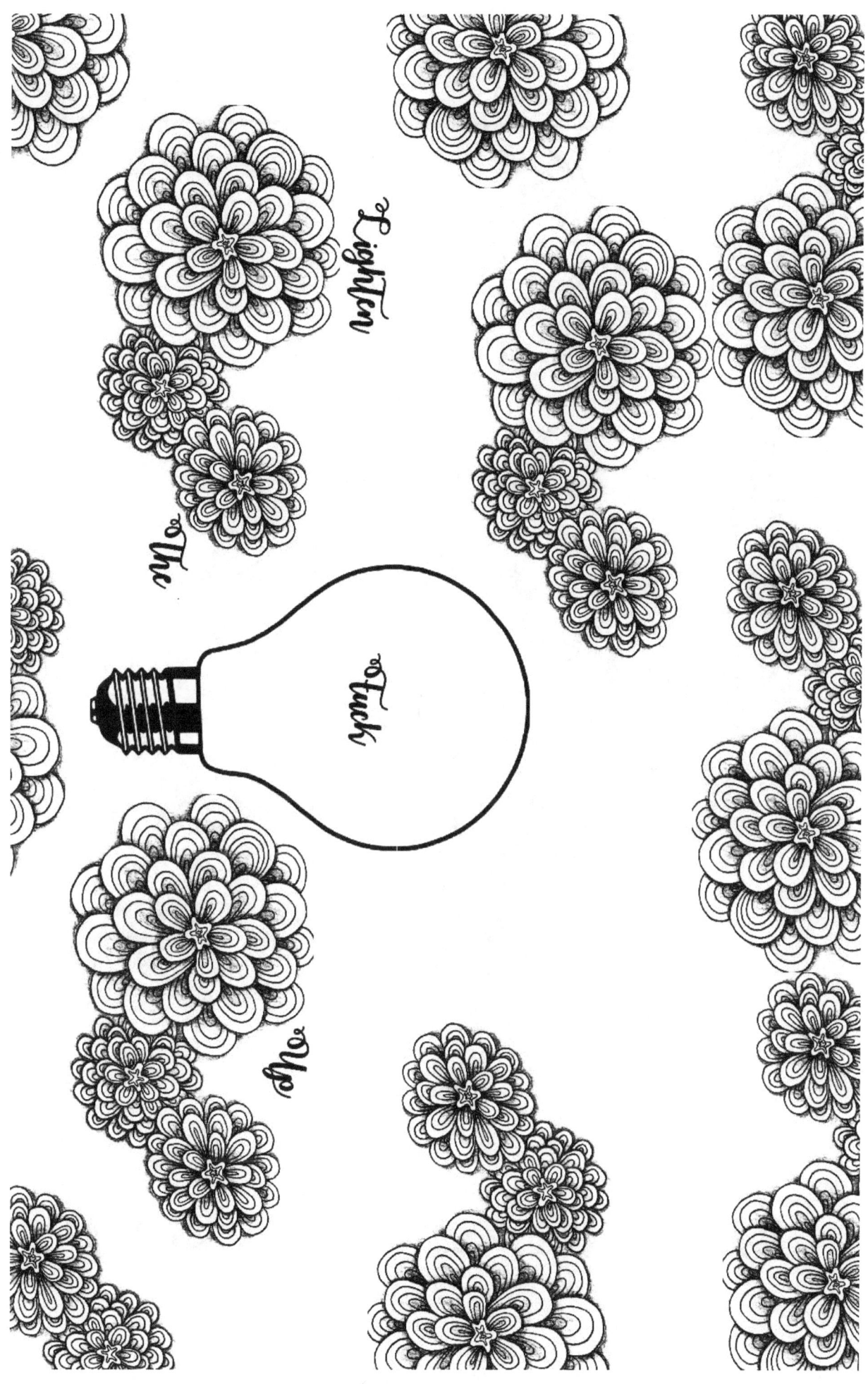

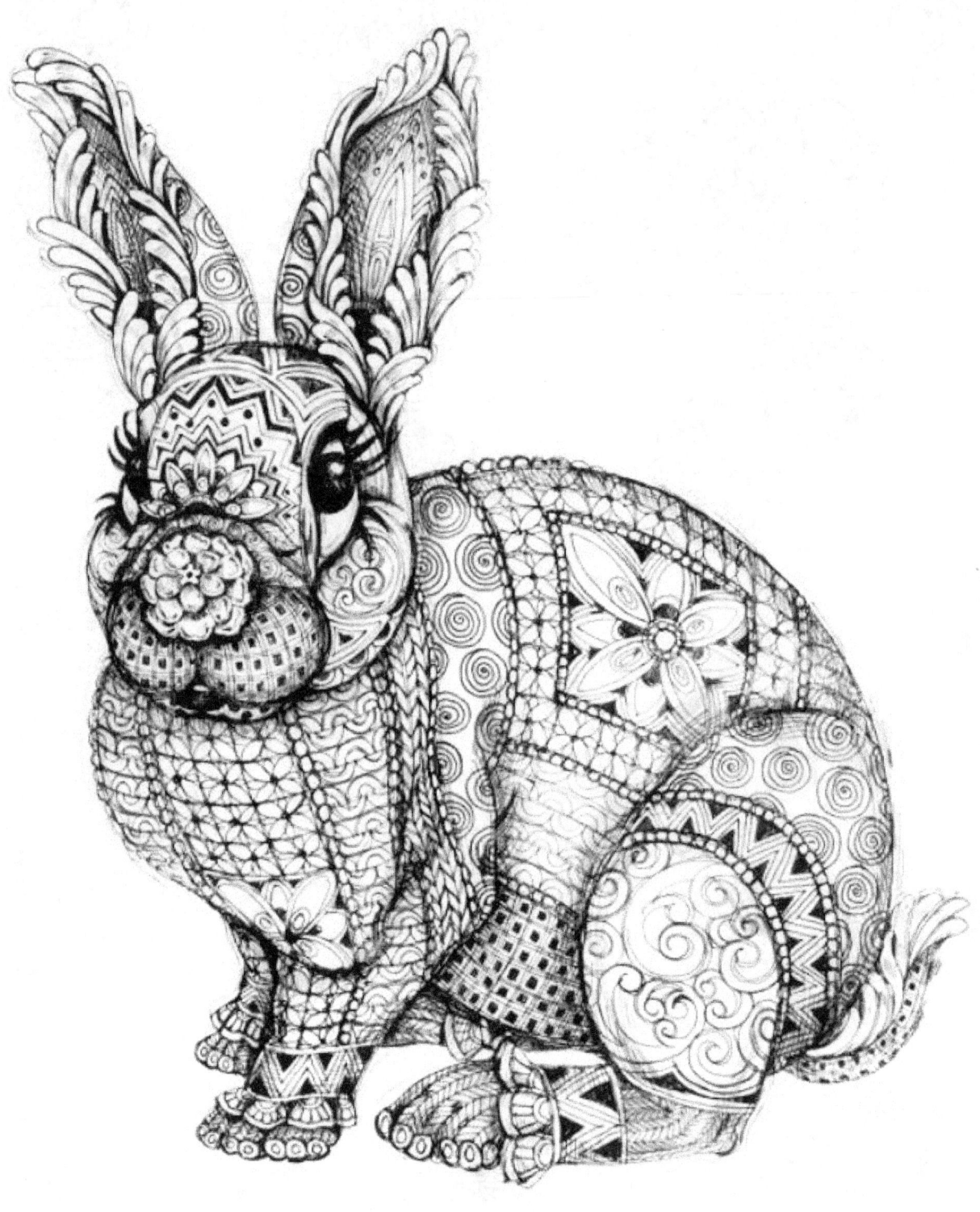

You've Lost Your Rabbit Ass Mind

www.ingramcontent.com/pod-product-compliance
Lightning Source LLC
Chambersburg PA
CBHW080611190526
45169CB00007B/2962